ODD JOBS

**Portraits of
Unusual
Occupations**

Odd
Jobs

Nancy Rica Schiff

Ten Speed Press
Berkeley / Toronto

Ten Speed Press
PO Box 7123
Berkeley, California 94707
www.tenspeed.com

Distributed in Australia by Simon and Schuster Australia, in Canada by Ten Speed Press Canada, in New Zealand by Southern Publishers Group, in South Africa by Real Books, and in the United Kingdom and Europe by Airlift Book Company.

Jacket design by Todd Heughens
Text design by Nancy Austin

Library of Congress Cataloging-in-Publication Data
Schiff, Nancy Rica.
 Odd jobs : portraits of unusual occupations / Nancy Rica Schiff.
 p. cm.
 ISBN-10: 1-58008-457-5
 ISBN-13: 978-1-58008-457-4
1. Portrait photography—United States. 2. Working class—United States—Portraits. 3. Occupations—United States—Pictorial works. I. Title.
TR681.W65 S35 2002
779'.2'092—dc21 2002005058

First printing, 2002
Printed in China

4 5 6 7 8 9 10 — 08 07 06 05

Introduction

Odd Jobs began by accident. There I was, doing a photo shoot at the Holly-wood Race Track in Los Angeles back in 1989. During the shoot, I noticed an interesting looking man with a glint in his one good eye. He appeared after every race, and it turned out that he was the official timekeeper for the track. Now there was a job I had never thought about.

The more I watched this fellow and reflected on what he did, the more I was drawn to the idea of photographing odd jobs. It was clear to me that some people belong to an unrecognized segment of our society, performing off-the-beaten-track jobs that taken together represent the unexpected side of life in America. I wanted to identify these people and find out all about them. Who are they? What are their daily lives like? And most of all, how could I find them and take their pictures?

The hunt was on. I combed newspapers and magazines for clues. I queried my friends and acquaintances for leads. I got everyone I knew talk-ing about odd jobs. One friend pointed me to a hospital, another to the Hockey Hall of Fame. I visited mountains and factories, and the collection grew. Now my days were spent on farms with earthworms, in barns with bulls, and at museums with feather dusters. Predictable jobs didn't interest me, so I didn't go after any circus people, acrobats, or sidewalk hawkers. I wanted truly quirky occupations, ones that live below the radar.

In the years since I began the project, one of my subjects has passed away, and I'm sure that some others have moved on to new employment. But at the time, each of these folks was performing his or her job with aplomb and dedi-cation. Unique jobs every one, not likely to be found in your local classifieds.

Condom Tester
Trenton, New Jersey

Betty Twarkusky worked for Carter Wallace, Inc. for over forty-six years.
You may not be familiar with Carter Wallace: they manufacture Trojan
condoms, among other things. Every single condom that leaves the factory
gets tested, and Betty, who has since retired, was one of many testers.
Working on an assembly line, testers place the condoms over steel mandrels
that heat up and are then submerged in water. Any hole or puncture will
immediately cause a condom to be rejected; if three condoms within a
group are rejected, the entire batch gets thrown out. More than one million
condoms are produced daily at this New Jersey plant, a true boon to popu-
lation control.

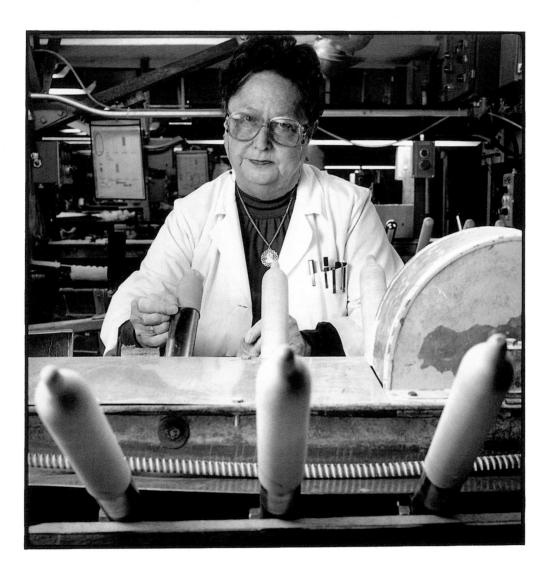

● **Page Turner**
New York, New York

He's not usually in the spotlight. In fact, his task demands that he be as inconspicuous as possible despite the fact that he's very tuned in and never misses a beat. Louis Yelnick is a page turner, and he's got the technique down to a finger-licking science. In places like Carnegie Hall or Avery Fisher Hall in New York City, he has turned the pages for the pianist who played for the violinist Itzhak Perlman. Mr. Yelnick describes his job as being "the man behind the man behind the man."

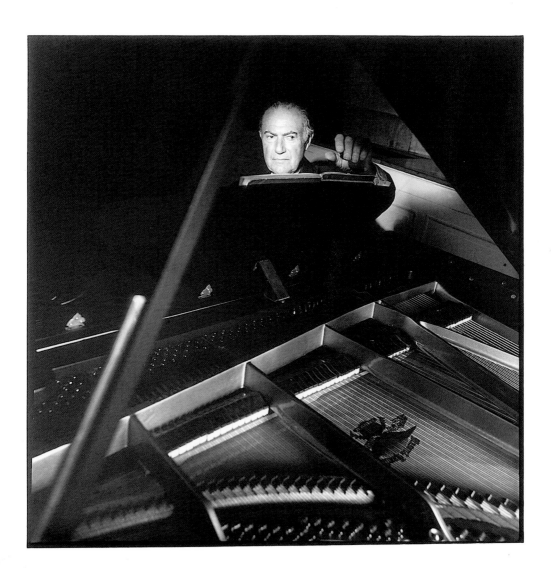

Dog Walker
New York, New York

A graduate of Marymount Manhattan College with a B.A. in economics, Tynee Birch Balkin makes her living walking dogs. For thirty-one years, she has been walking as many as twenty dogs at a time on New York City's Upper East Side. Rain or shine, she takes her canine pack on ambles through Central Park for a half hour, one hour, or three hours, depending on the pet owners' wishes. Tynee has four chihuahuas of her own, as well as two cats and five birds. Nowadays, she also has an assistant—her seven-year-old daughter.

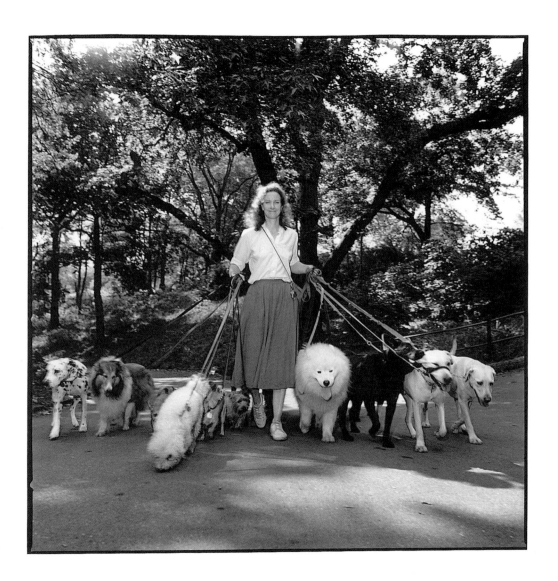

● **Coffin Maker**
Christoval, Texas

If knowing where your body will be laid to rest will help you rest easier, Doug Keys is your man. He will make you a coffin and won't charge an arm and a leg for it. His caskets are custom-made, ranging from simple pine boxes to treasure chests inlaid with jewels. Don't worry if you're not quite ready for the sweet hereafter. For a mere ninety dollars, he will store a coffin for as long as five years.

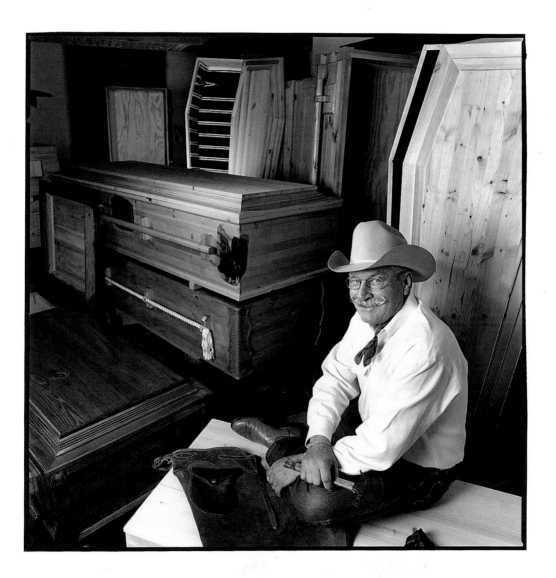

Potato Chip Inspector
Hyannis, Massachusetts

One potato, two potatoes, three potatoes, four—what can a potato chip inspector be looking for? According to Cindy Pina at the Cape Cod Potato Chip Factory in Hyannis, Massachusetts, she looks for over-cooked chips, but more importantly, for chips that are clumped together. Such clumps will ruin the whole bag. Cindy has been inspecting potato chips for twelve years and, she admits, eats far fewer chips today than when she began the job. She also reveals an occupational hazard: when she does eat chips, she can't keep herself from inspecting them closely.

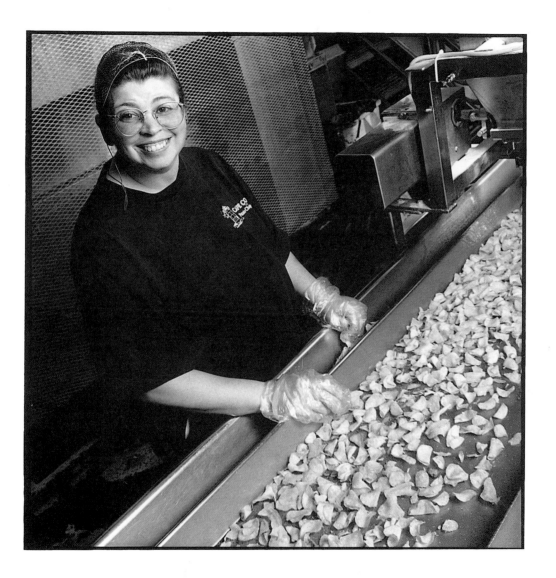

Baby Handler
New York, New York

Josef Schneider created his job as baby handler by chance. It all started in the 1960s when he was working as a casting agent. Several hours after sending out a dozen bright-eyed, beautiful babies for a Pampers photo shoot, Josef got a call from the harried photographer seeking advice on how to control the diapered dozen. He went over to lend a hand, thus launching his new career. Josef reveals his best attention-getting gimmick—a brightly colored cloth, preferably red, which babies, like bulls, find irresistible.

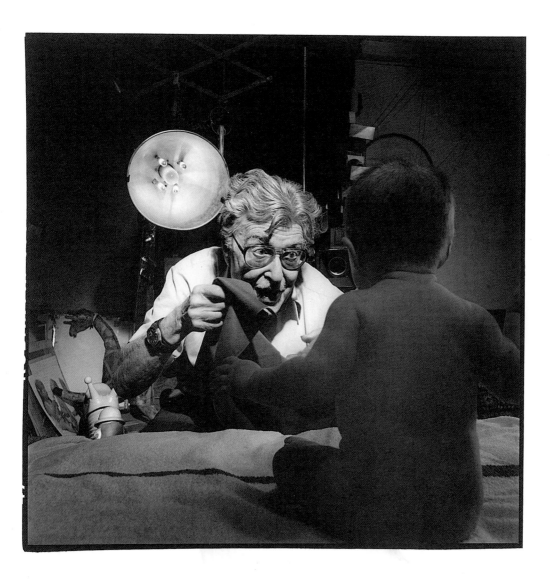

Bingo Caller
Indio, California

At Fantasy Springs Casino in the middle of the Mohave Desert, a hush falls over the room whenever Veronica Zarate utters a word. Seven-hundred-and-fifty players listen with rapt attention as she calls out the combination of Bingo letters and numbers from balls popping up before her at fifteen-second intervals. A day's worth of playing, at a cost of $22.50, can win a player as much as $2,500 in the highest stakes games. Veronica may not be a diva, but for the jackpot winners, she definitely has a voice of gold.

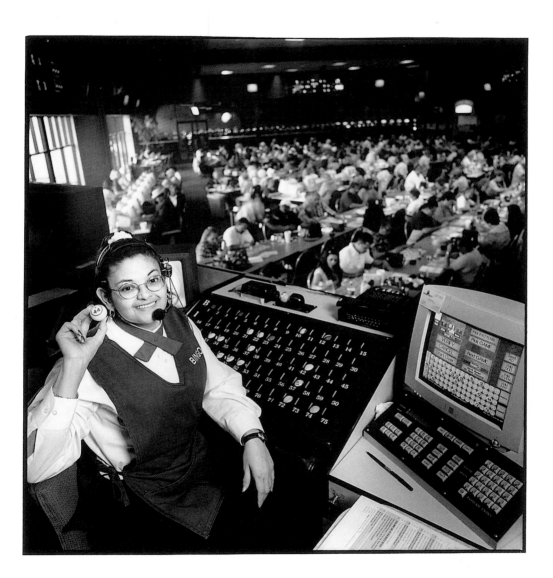

Roller Coaster Operator
Brooklyn, New York

Born and raised in Coney Island, Anthony Marinaccio has never ventured far from home. For more than twenty years, beginning on Easter Sunday and ending on Labor Day, Anthony has operated the world-famous Cyclone Roller Coaster in Coney Island, once known as Steeplechase Park. It's the same wooden roller coaster that was built in the early part of the twentieth century, and it works by the force of gravity. Anthony points out that the heavier the load, the faster the ride. When he's aboard, he quips, he feels as though he's traveling at the speed of light.

Bra Designer
New York, New York

Don Allen knows a perfect 34C when he sees one. A designer of brassieres and panties, he spends his days measuring, fitting, and gossiping with real live models with perfect breasts. Having grown up with a father who worked for Playtex, this job was a natural. Ask him about sink-in, high points, cross cups, cookies, and entry and he waxes eloquent. Those are the technical terms that fill his conversations, along with all the latest industry buzz.

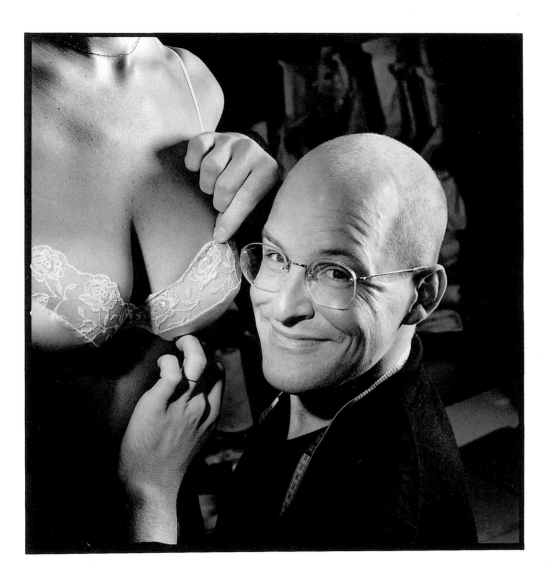

● Wax Figure Maker
Baltimore, Maryland

Can you guess which figure is the real one, and his name? It's Robert Dorfman, son of Earl Dorfman (also pictured here), who started the business of manufacturing lifelike human models over forty years ago. The Dorfmans started out as a supplier to commercial wax museums, and today their dummies are being used to dramatize scientific and historical displays in traditional museums all over the world from Cape Cod to Singapore. Three generations of Dorfmans are included in this family portrait, which also includes the likes of Thomas Jefferson and Betsy Ross.

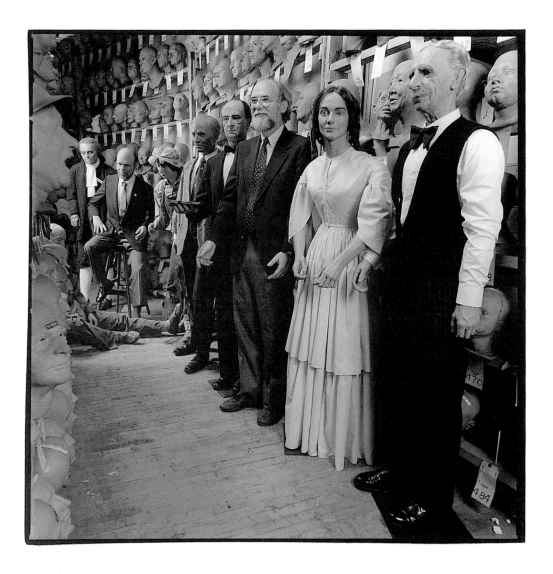

Sparring Partner
Brooklyn, New York

Contrary to popular custom, Chuck Colbert makes his boss work hard for his money. The two of them square off every weekday morning from seven to nine in the boxing ring at Gleason's Gym in Brooklyn, where Chuck is his boss's sparring partner. After two hours of ferocious body blows and right jabs, the two shower and amicably head into Manhattan in a chauffeured limo. Chuck then attacks his other job—as mailroom attendant at the insurance brokerage firm headed by that self-same boss.

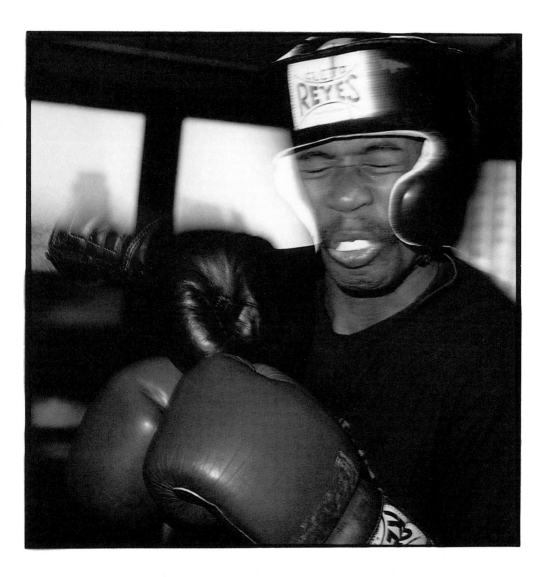

Artificial Inseminator
La Sal, Utah

As a theriogenologist, Jim O'Neal is handy at his work, artificially insemi-nating hundreds of heifers a day. From late April through late June, Jim can be found visiting one of the many ranches he services in his custom-built trailer. He doesn't roll up his sleeves but, as you can see, he unzips his specially designed work suit, dons a plastic glove that covers the entire length of his arm, and reaches deep inside the cow. As soon as he feels her cervix, he injects her with six to ten million live sperm contained in a vial he holds in his other hand. With a 65 to 70 percent pregnancy rate, his success is undeniable.

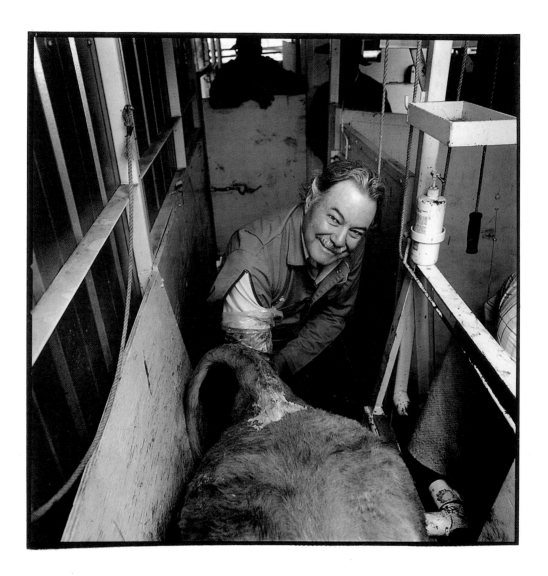

Foot Model
New York, New York

When most models walk into the photographer's studio, they apply makeup to their faces. Ellen Sirot puts makeup on her feet. She is one of New York City's busiest foot models, also known as a parts model. If she's on her toes, she can earn up to $300 an hour. The preparation for her job involves putting gobs of cream on her feet every night before bedtime, covering them with plastic bags, and sleeping with them elevated. She gets a pedicure regularly and never wears high heels. This is a gal who puts her best foot forward every workday hour.

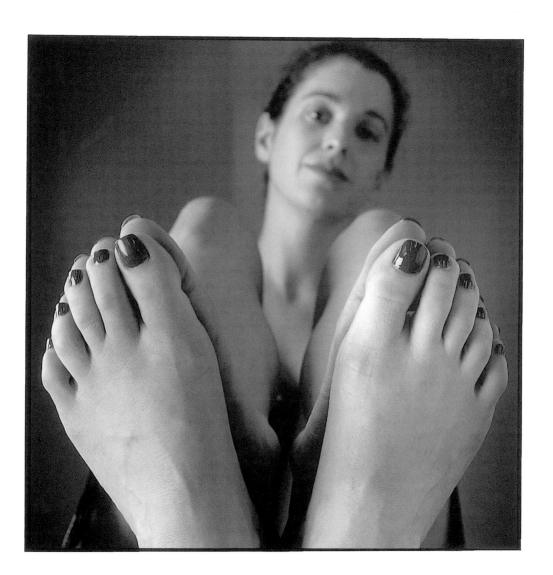

Dinosaur Duster
Washington, D.C.

For over thirty years, Frank Braisted has been dusting 145-million-year-old bones. Frank is the one and only dinosaur duster at the Smithsonian Museum of Natural History in Washington, D.C. Five days a week in the early hours of the morning, he has the dinosaurs all to himself as he grooms them with a feather duster and a vacuum cleaner. One thing he never does, however, is touch the bones. Here Frank appears with the Stegosaurus, a plant-eater known for its small head and slender jaws. He admits, though, that his favorite is the Allosaurus, a meat-eater with impressive teeth and claws.

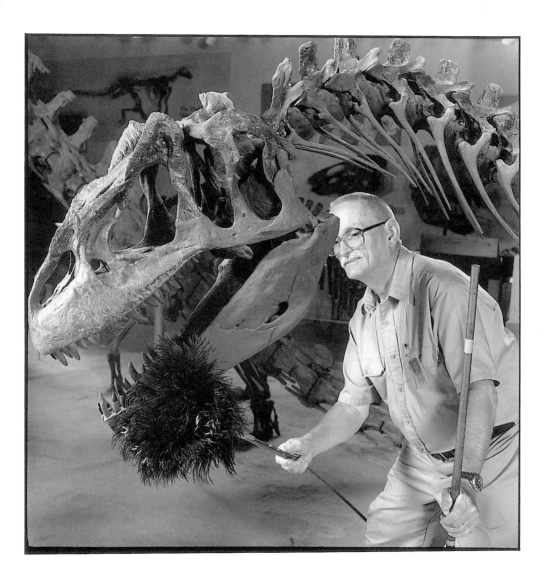

Curator
New York, New York

He calls himself the "Keeper of the Earth," and that's exactly what
Bill Dilworth is. He waters and rakes the earth once a week in Walter
DeMaria's New York Earth Room, a permanent sculpture in the Soho
section of Manhattan visited by thousands of art enthusiasts every year.
The Earth Room is a 3,600-square-foot loft filled with 250 cubic yards of
earth, 22 inches deep and weighing 280,000 pounds. Look closely and you
might just see an occasional mushroom cap peeking through the soil.

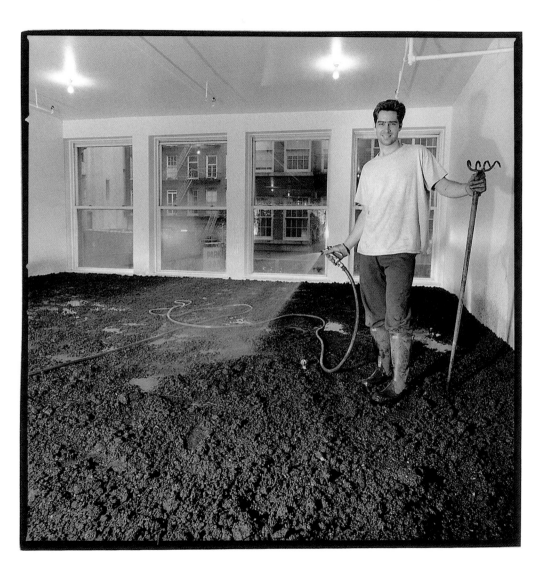

Golf Ball Diver
Kissimmee, Florida

Jeffrey Bleim says his work is always "picking up." Clad in three layers of wetsuits and towing forty-five pounds of scuba gear, eighteen pounds of weights at his waist, and sixty pounds of golf balls in a net hanging from his neck, he glides through the waters of Orlando-area golf courses picking up after the mistakes of others. On a typical day like this one at Falcon's Fire Golf Course, he scores 5,000 balls, making his weekly take 25,000. Last year he retrieved 800,000 balls, weighing in at forty tons. He ships them off to a refinishing company, which in turn sells them for half price. Jeffrey's take: somewhere between five and ten cents a ball.

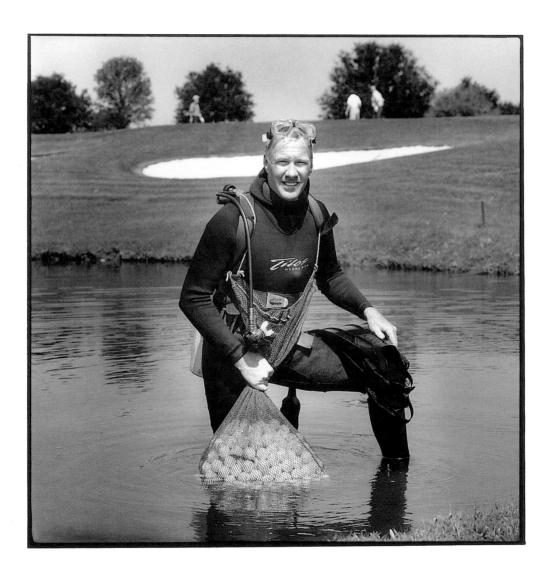

Crime Scene Photographer
New York, New York

Hal Sherman shoots a lot more with his Mamiya 645 than with his Smith
and Wesson Special Model 36. A twenty-year veteran of the NYPD and one
of the youngest cops of his rank, Hal has been working in the crime scene
unit as a photographer since 1987 and was promoted to first-grade detective
in 2001. You won't see his photographs in any art galleries, but they are
exhibited rather frequently in courthouses all over the city.

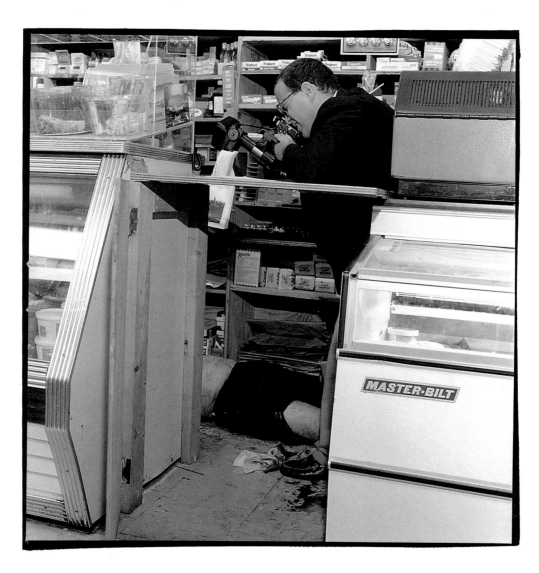

Dog Sniffer
Topeka, Kansas

There are 700 dogs, mostly beagles, on site at Hill's Pet Nutrition in Topeka, Kansas. The odor of their breath is analyzed once a week in order to test the effect of their diet on their teeth. Hill's prides itself on making dog food that eliminates plaque build-up and fights gingivitis. Roxanne Livgren has been trained to sniff the dogs' breath to determine the state of their health and the effectiveness of the dog food. Buster here's breath is graded on a scale of zero to ten and can be categorized as sweaty, salty, musty, fungal, or decaying.

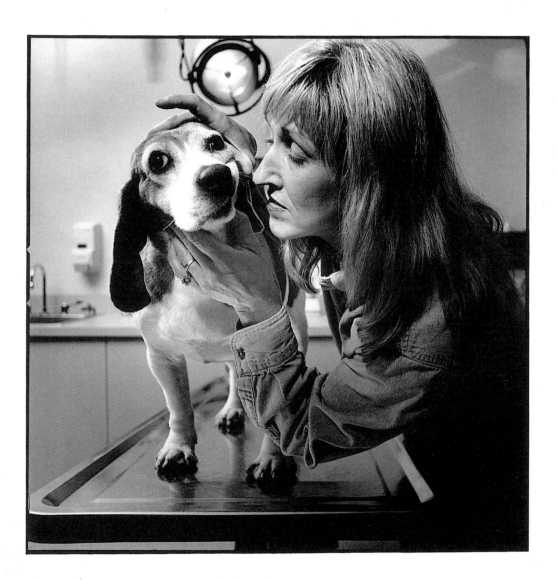

- **Doll Doctor**
New York, New York

The fact that this hospital is one of the least orderly in New York City doesn't seem to discourage its patients. Drawn by the 100-year-old New York Doll Hospital's sterling reputation, they arrive in droves from every corner of the Earth for a myriad of operations from plastic surgery to limb replacements. Irving Chais, head doctor in residence, can boast of a record many doctors would envy: all of his transplants have been successful, and he's never yet lost—or misplaced—a patient.

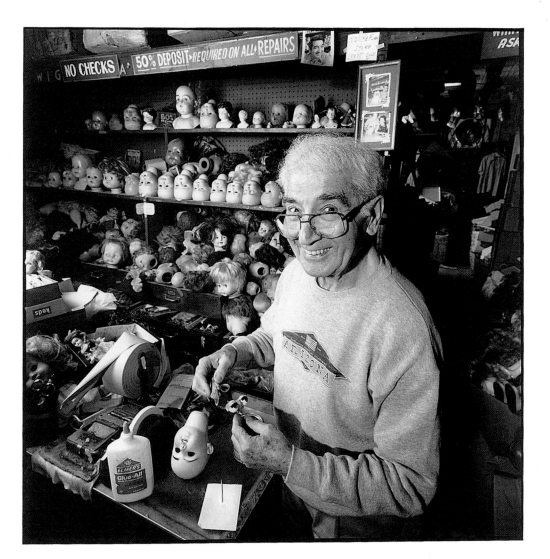

Porta-Potty Serviceman
Abilene, Texas

Ask Lou Paulsen what business he's in, and he replies, "in the number one and number two business." He means that quite literally. His company, Can Doo, has 450 porta-potties at their disposal, you might say. Scattered all over Abilene and San Angelo, Texas, these self-contained facilities require servicing once a week to live up to Paulsen's standard of cleanliness. His company's motto: "No Gamble, the Pot's Right."

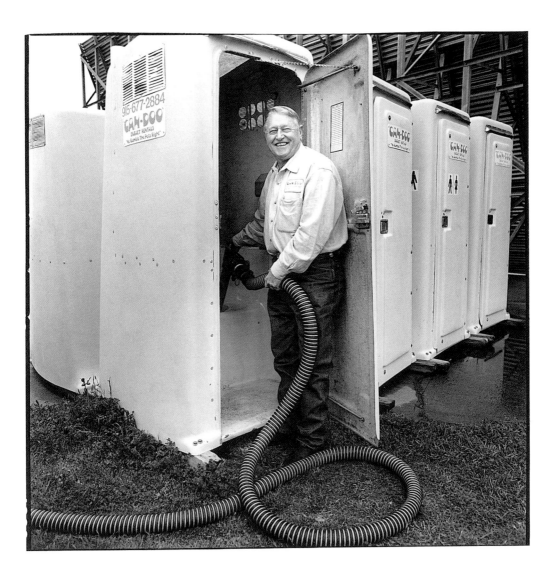

Egg Inspector
Indiantown, Florida

At the Indiantown Egg Company, hundreds of thousands of chickens are busy laying eggs day and night. It's no easy task keeping up with them, but that's exactly what David Trent is paid for by the government. Ensconced in a far corner of the plant in a small room that's painted black, he holds, or "candles," the eggs in front of a small light to look for blood spots or cracks in the shells. He takes a sampling for ten minutes every hour so that the eggs can be graded and given the USDA stamp of approval. David can examine one hundred eggs in five minutes flat.

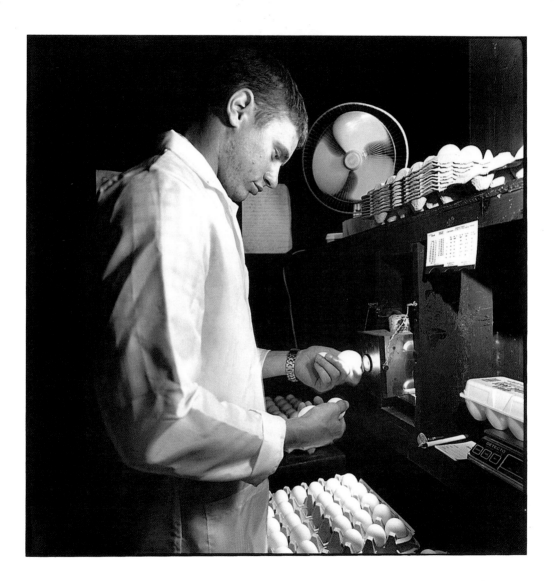

Mohel

New York, New York

Eight days after birth, Jewish baby boys have a bris given by the proud parents, and it is the job of a mohel to perform the ritual circumcision. Traditionally, the grandfather holds the infant while the mohel does his work. As is typical of mohels, Philip Sherman does quote a fee for his services, but if a family cannot meet the fee, he will graciously accept whatever they can afford. Afterward, there's a festive meal for eating, drinking, and merry-making. It's a joyous occasion for all—well, almost all.

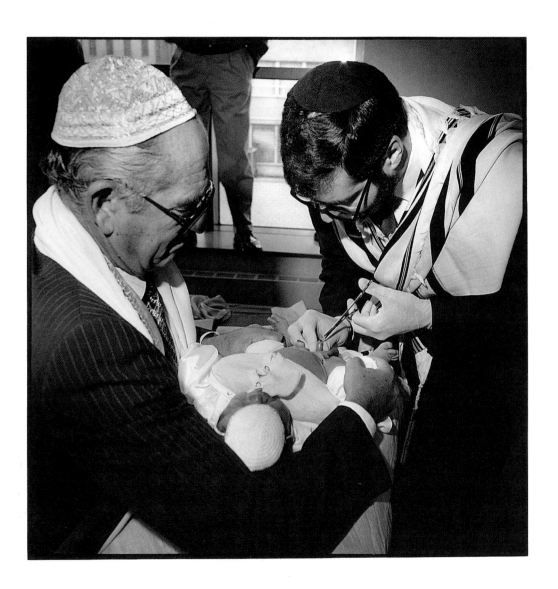

● Men's Room Attendant
New York, New York

There's nothing odd about being a men's room attendant—unless you're a woman. Tina Little fell into her job at the posh Manhattan supper club Laura Belle when asked to fill in for her ailing predecessor. After a night of double-takes and rueful remarks from the stunned gentlemen (the most common one: "stage fright"), Tina went home with $300 in her pocket. Not bad for some harmless patter.

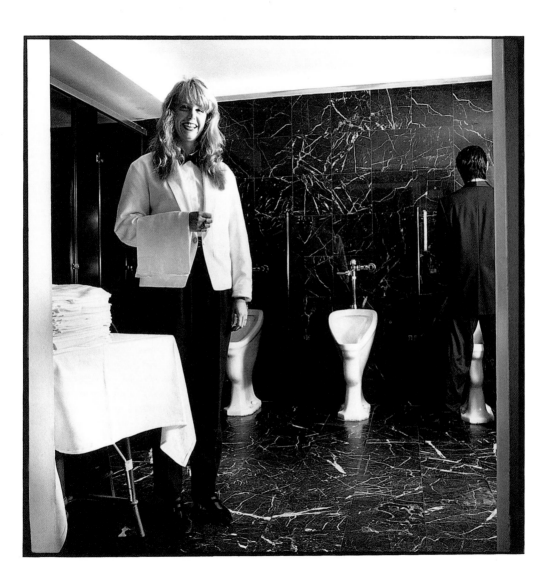

● **Coin Polisher**
San Francisco, California

The St. Francis Hotel in San Francisco has been laundering their money for
more than fifty years; and for twenty of those years, Arnold Batliner was the
man in charge. Every weekday morning, Arnold went to work shining all
the quarters, dimes, nickels, and pennies by passing them through an old
silverware polisher borrowed from the kitchen. Arnold passed away several
years ago. All the old-timers at the hotel remember *him* as the real treasure.

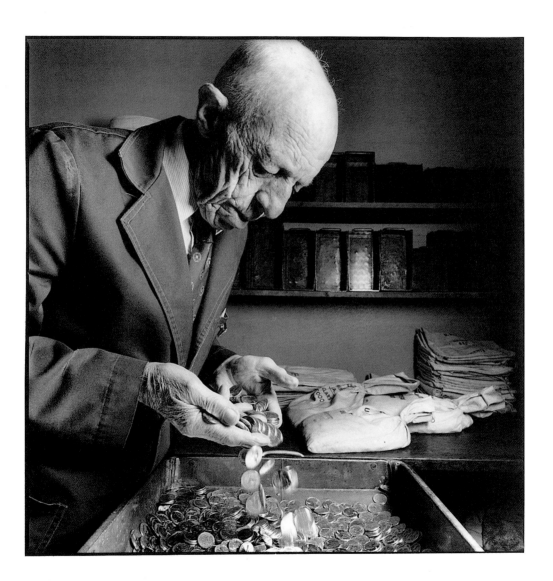

Knife Thrower's Assistant
El Cajon, California

Knife throwing is an odd job, but the work of the knife thrower's assistant is even odder. When Jennifer Kelley was deciding whether to take the job, she studied hours of taped performances by world-renowned knife thrower Larry Cisewski. Obviously, what she saw did not deter her. Jennifer now performs various daring acts, serving as a live target while spinning on a wheel or hiding behind a large paper screen. The only safe part of her job is inflating balloons. Larry won a Guinness world record by outlining Jennifer's slight frame with eight steel hachets thrown in a mere thirty seconds, and she is here as living testimony to his skill.

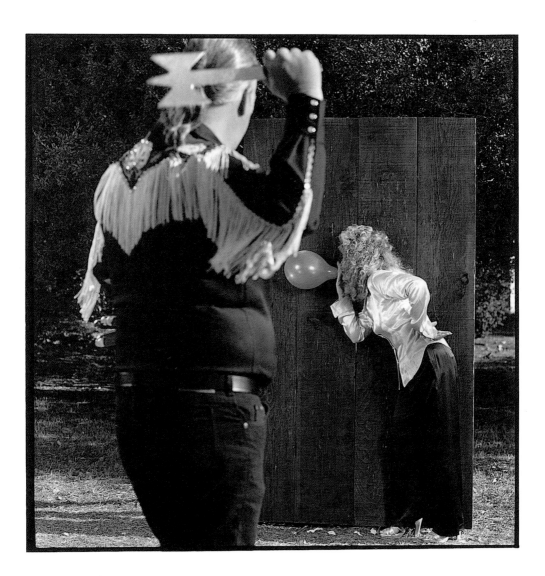

Odor Judge
Cincinnati, Ohio

At fifty-year-old Hilltop Labs in Cincinnati, odor tests are conducted daily on axillae (better known as armpits), breath, feet, cat litter, and diapers. Here a test is being performed on a subject who has followed strict protocol for the deodorant efficacy study. Betty Lyons began her career thirty-five years ago when she herself was a subject. She then trained for almost a year and is still tested monthly to measure her acuity. Odors are judged on a scale of one to ten, and most odor judges are women: they are able to make finer distinctions.

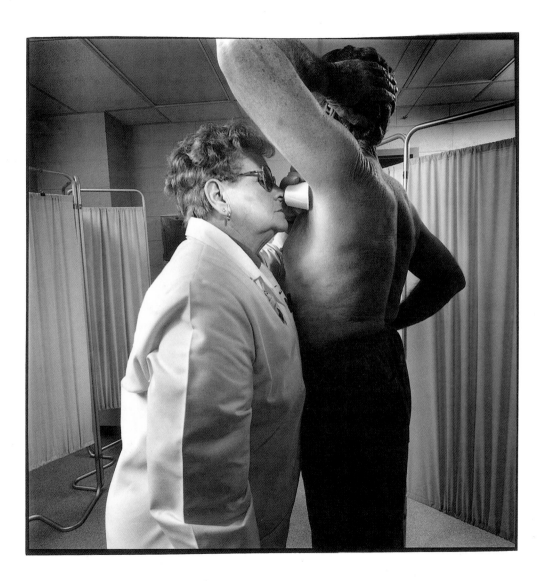

Funeral Parlor Cosmetologist
Brooklyn, New York

Claudia DeJohn-Saraceno doesn't take bookings in advance, but she's on call day and night for her hair and makeup skills. Her task is to ready the deceased for their last appearance before family and friends. Unlike other cosmetologists who work under bright lights, she works in the same low-light conditions under which her subjects will later be viewed and uses special makeup suited to their colder body temperature. To make her clients look as they did during their lifetime, she sometimes works from photographs. The funeral business seems to run in Claudia's family—both her brother and her husband are licensed funeral directors.

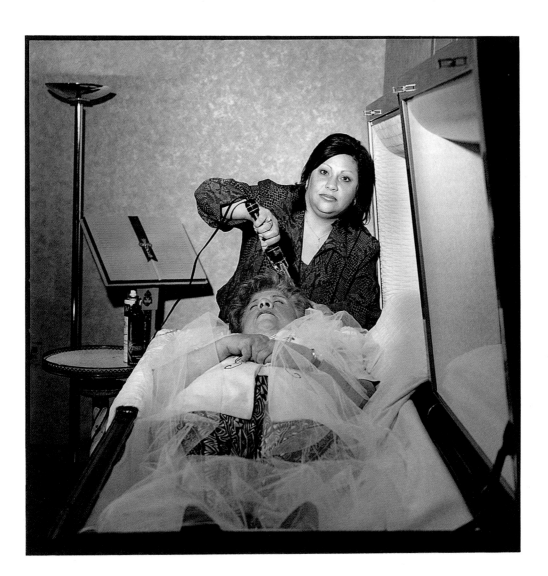

Horse Anesthetist
Grand Junction, Colorado

For two-and-a-half to three hours per surgical procedure, Valarie Boudreaux holds the life of every patient in her hands. All of her patients at the Harris Equine Hospital in Grand Junction, Colorado, are horses. She's on call any time of the day for emergencies, and she averages one to two operations a week. Once her patient has been intubated and is inhaling halothane, Valarie monitors its heart and respiration rates, as well as its mean blood pressure. Valarie takes whatever comes from the horse's mouth very seriously.

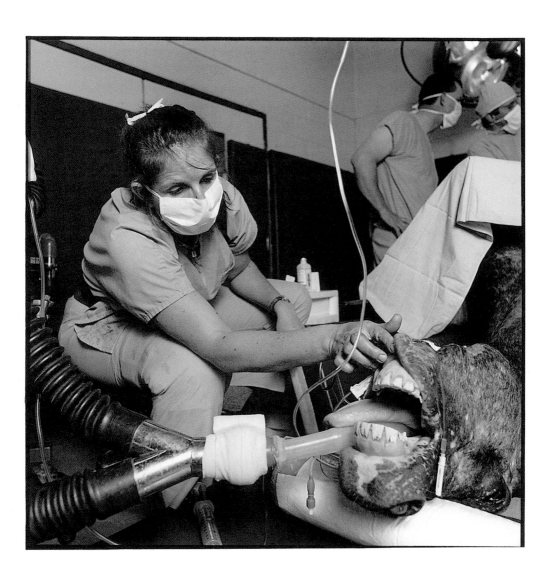

Solfeggist
New York, New York

ASCAP, the American Society of Composers and Publishers, employs a dozen or so monitors who listen to taped radio programs all day long. To be awarded a job like this, applicants must pass a test correctly identifying at least thirty-five out of forty songs of all types from classical to rock to heavy metal. The head tape monitor, Neal Haiduck, is the solfeggist. His job is to write down the musical notes of the compositions that can't be identified and to maintain a card catalog of this music. His notes are the do's, re's, and mi's of an extensive library of music.

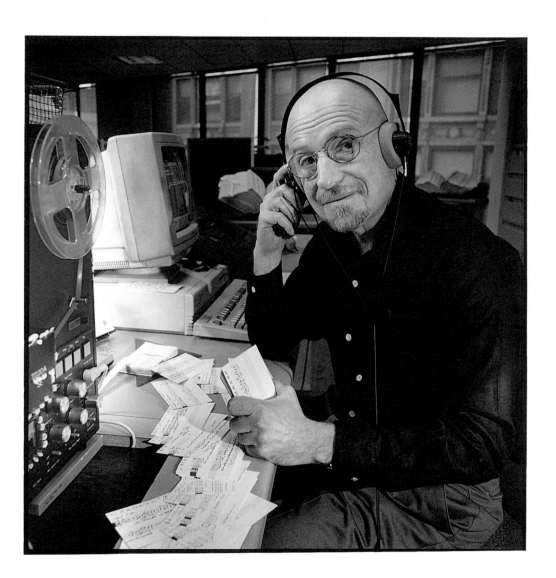

Barbie's Dress Designer
El Segundo, California

Her celebrity client is over forty years old, world famous, and a superstar with a perfect 5 1/2 by 3 1/2 by 5-inch figure. As chief fashion designer at Mattel Toys, Kitty Black Perkins, along with forty other designers, creates hundreds of new styles each year for Barbie and her growing family. Barbie now has eight relatives and thirty-two friends, all of whom need constant wardrobe updating. Luckily for Kitty and her crew, none of their clients ever gains an ounce.

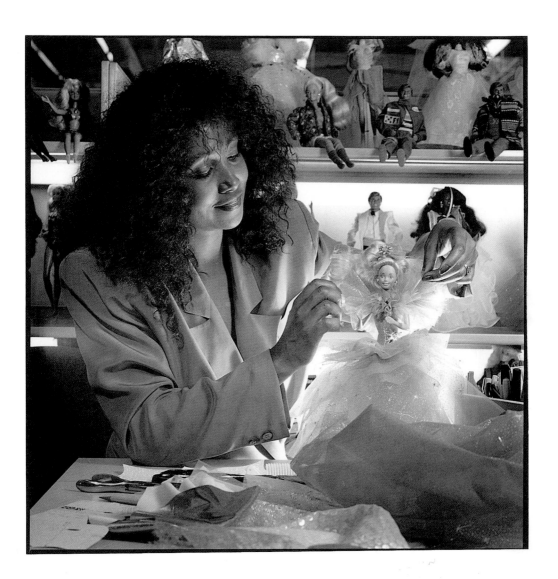

Scoreboard Operator
Boston, Massachusetts

The Green Monster, known to most Bostonians and to every baseball fan, is located at Boston's Fenway Park. It is one of the few manually operated scoreboards remaining in the U.S. and it stands thirty-seven feet high. The work space behind the wall is a dark and dusty corridor with narrow slits for changing the numbers or for watching the game. Chris Elias has held the position of scoreboard operator for twelve years and counting. Here he is hurrying to finish his pre-game duties before taking up his prized post behind the Green Monster.

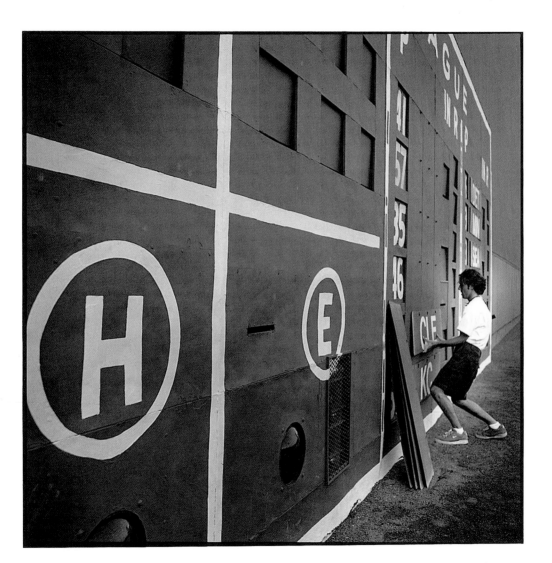

● Clockmaster
New York, New York

At precisely nine every Thursday morning, Marvin Schneider climbs the circular staircase leading up to New York City's largest mechanical clock atop the Federal Building on lower Broadway. This former civil servant first began his service on his own time, so to speak. Having noticed that the clock was in significant disrepair, he volunteered to care for the magnificent timepiece. In fact, he did so for six years before the city named him official Clockmaster of New York. Today, he is paid for the oiling, winding, changing of light bulbs, and repairing of several clocks owned by the city.

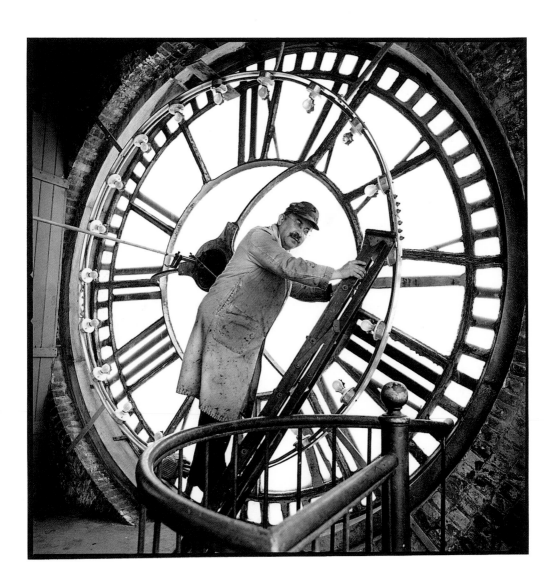

Private Zoo Keeper

Los Angeles, California

As an undergraduate student in biology in 1975, John Heston was offered the job of organizing and overseeing a growing collection of exotic animals in an unusual setting. The private zoo he has created boasts some 130 different species of animals—exotic birds, rare mammals, and ponds connected by streams and waterfalls where koi of every color swim. Sound like paradise? It is. But why is John sitting here with a bunny rabbit? The zoo he keeps is at Hugh Hefner's Playboy Mansion in the Bel Air section of Los Angeles.

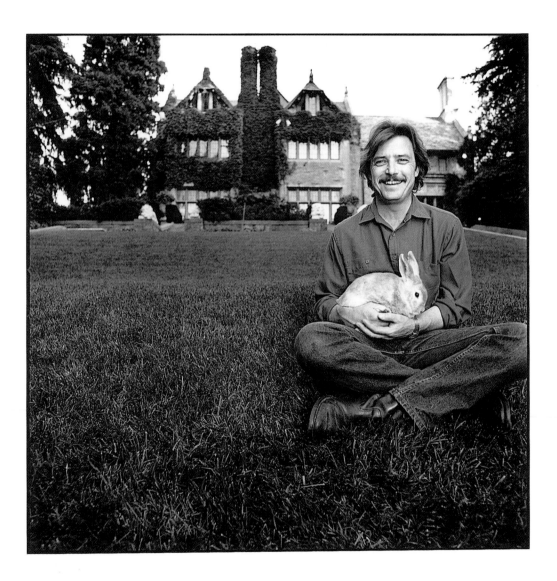

Semen Collector
DeForest, Wisconsin

Every day is filled with excitement at ABS Global, Inc. in DeForest, Wisconsin. More than 150 ejaculating bulls provide semen three to four times a day. Eliza Roberts, manager of semen collection, has worked at ABS for twenty years. She jokingly claims to have "shoveled her way up through the ranks and up through the bullshit." In a typical day, she and her colleagues collect some 30,000 units of semen. In a year, that mounts up to over six million acceptable units.

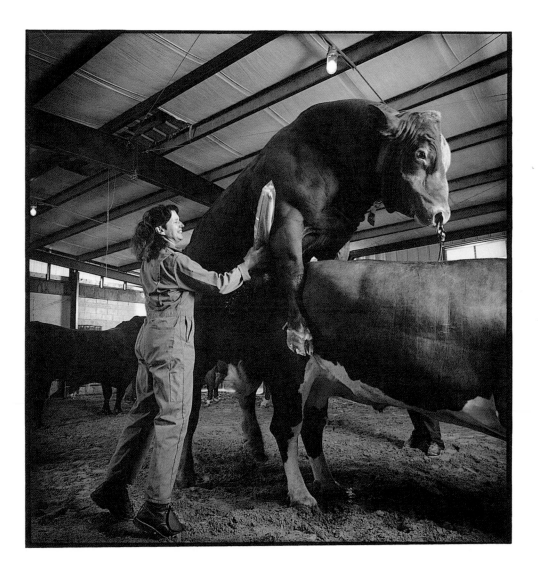

● Safe Cracker
New York, New York

It's all in the sound and the feel of it—cracking open a safe without the combination. Sal Schillizzi acquired his skill in the 1950s while serving in the U.S. Army. After his military stint was over, he opened a security store and continued practicing his craft professionally—and legally. He's a true expert on locks. When combinations are forgotten, he deftly solves the problem with his fingers and ears.

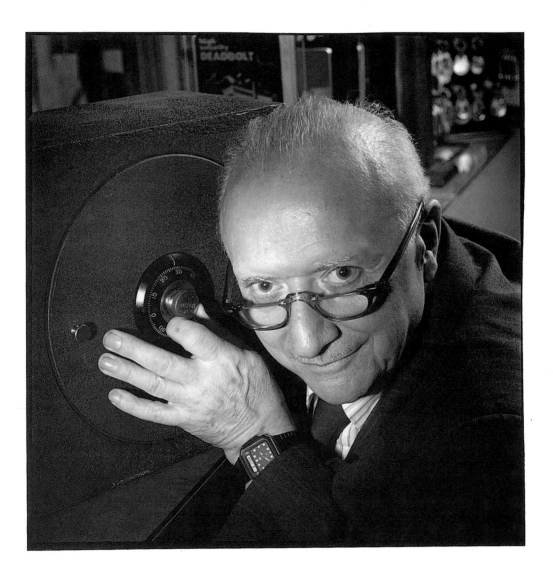

LEGO Model Maker
Enfield, Connecticut

At three years of age, Francie Berger started playing with LEGOs. In college at Virginia Tech, her architectural thesis was designing a large working farm using only LEGOs in the construction. Upon graduation, she applied for a job at LEGO, then confidently went off on a three-month holiday. By the time she returned home, LEGO was looking for her. Today Berger can build whatever she likes from an endless supply of blocks. Her favorite creations include a six-foot-tall surfing hippo and a fifty-four-inch-diameter model of the Aztec sun calendar.

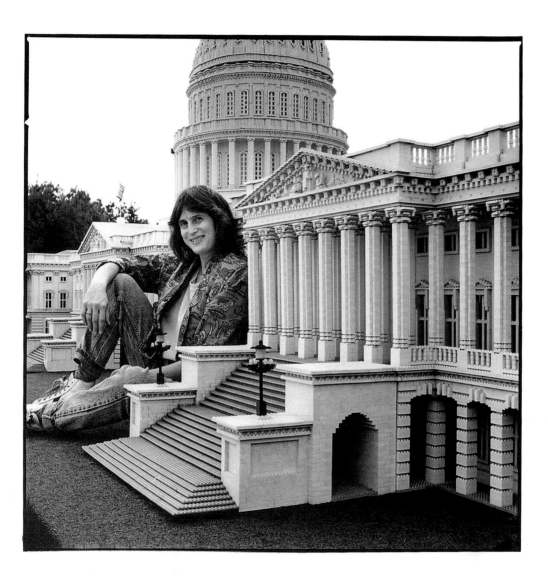

Diener
New York, New York

There's a diener (pronounced dee-ner) in most hospitals, and at this busy New York hospital, the diener's name is Larry Gee. He's a happy-go-lucky guy whose job it is to prepare cadavers for the pathologist before autopsies are performed. Larry likes his job because he's fascinated by human anatomy. However, he often gets kidded by friends who claim they're "dying to do business with him."

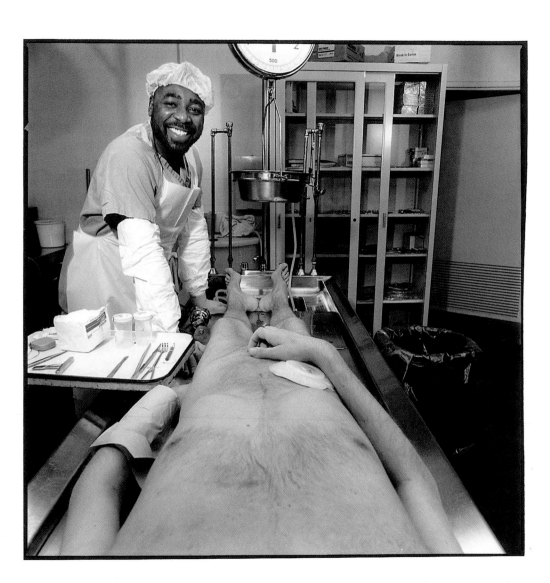

Hotdoggers
Denver, Colorado

From more than 1,000 applicants from colleges all over the U.S., the Oscar Mayer Weiner Company picks twelve seniors a year to work as hotdoggers. The job entails traveling the country in a five-ton, twenty-seven-foot-long, ten-and-a-half-foot-high car shaped like a hot dog. This custom-made car sports a hotdog-shaped dashboard, state-of-the-art video equipment, and a rearview mirror made from a large-screen TV. Hotdoggers Amy Sticco and Michael Batka enjoy being oohed and aahed wherever they appear, on the highway, outside their hotel, or in the parking lot at the local mall.

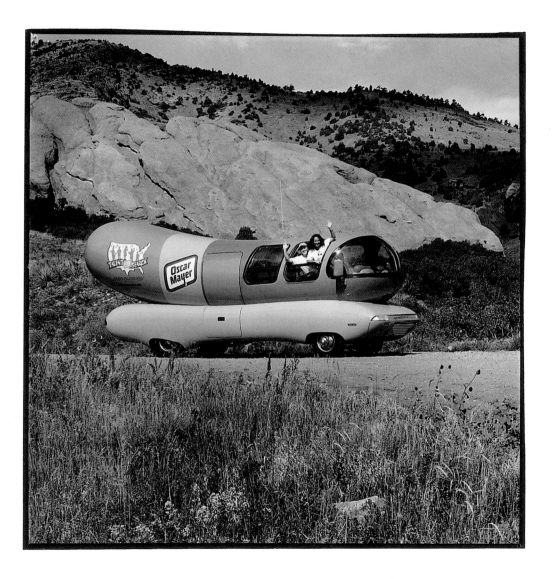

Perfumer
New York, New York

Call her nosey and Sophia Grojsman won't mind. In fact, she'll tell you it's all in a day's work. Employed for thirty-five years at International Flavors and Fragrances, she spends her working hours sniffing her way to perfection. With her unusually gifted olfactory organ, she has blended some of the best-selling fragrances of our day, from Elizabeth Taylor's "Diamonds and Rubies" to Yves Saint Laurent's "Paris" to Calvin Klein's "Eternity for Women." Happily, her very fine sense for scents has given her more than a passing familiarity with the sweet smell of success.

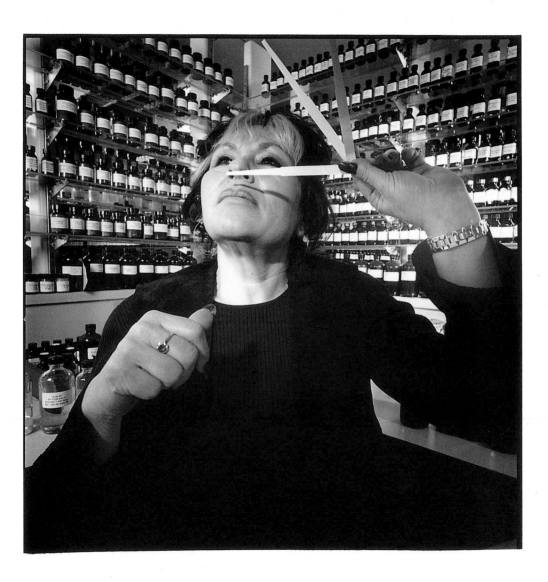

Earthworm Farmer
Trinidad, Colorado

Peter Chase got into raising earthworms when he learned how little care they require. He feeds them worm chow, a corn meal made by Purina, and is quick to explain that worms will eat anything that was once alive, even cardboard. The worms are housed in twenty beds of soil in a garage with little light. They are not sold as bait for fishermen, but as garden compost helpers or to other would-be farmers. The average order is a five-pound box with approximately one thousand worms per pound, or five thousand worms in all. He ships them via U.S. priority mail, packed in a *waxed* cardboard box.

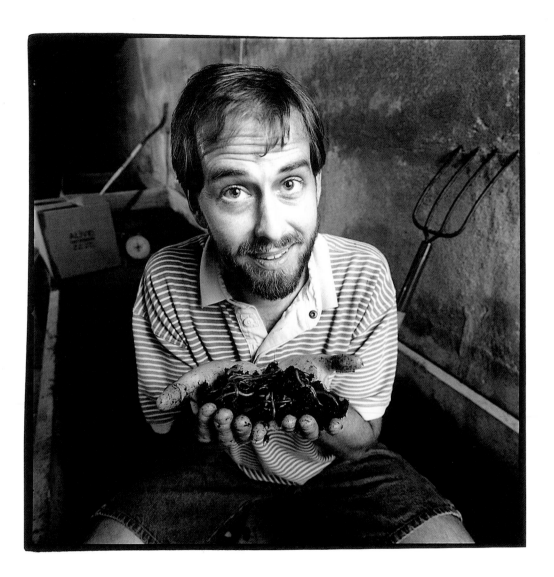

Foley Artist
New York, New York

When you watch a film, it may be okay to believe what you see, but not what you hear. Every footstep, knock, rattle, tap, and creak is made in the foley artist's studio, a soundproof room possessing a microphone and every conceivable type of junk used to create sound effects. Marko Costanzo has worked on such varied films as *Silence of the Lambs, Men in Black,* and *The Age of Innocence.* His talent shines most when he's asked to make a sound that conveys an emotion, such as placing a glass down "fearfully." Marko calls this the art of making a sound for something that has no sound.

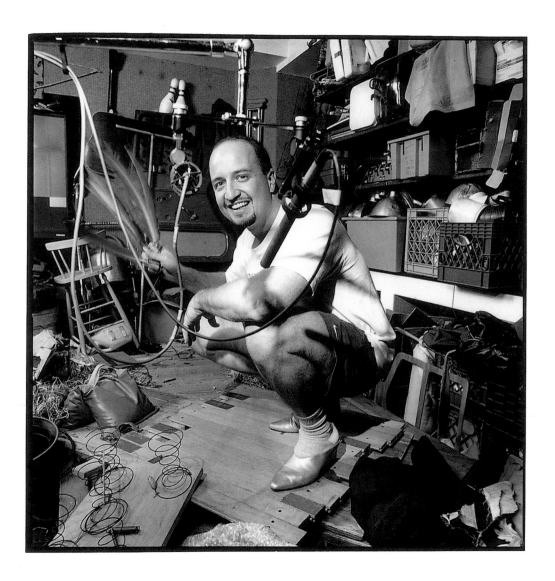

Route Setter
Santa Cruz, California

A route setter is a modern-day trailblazer—and trailblazing is a job as old as the hills. Twice a week, Zach Gardner changes the routes up the indoor climbing walls at the Pacific Edge Climbing Gym in Santa Cruz, California. The gym features 13,000 square feet of 50-foot-tall, state-of-the-art climbing terrain. When Zach completes each route, he signs his name like any artist would, so that climbers will know whom to thank for their trek.

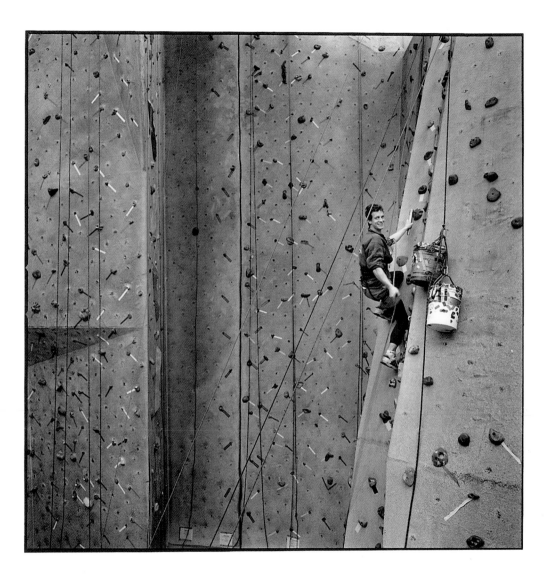

Ocularist
New York, New York

The eyes have it for Annette Kirszrot. Intrigued by the art of painting artificial eyes, she learned her craft from a fellow ocularist thirty years ago and has been painting ever since. Surprisingly, the number of people who have a prosthetic eye, most of which result from accidents or malignant tumors, is very high and, as with real eyes, no two are ever alike. For Kirszrot, much of the gratification of her work comes from changing people's lives for the better. Though she can't affect how they see, she can improve how they look.

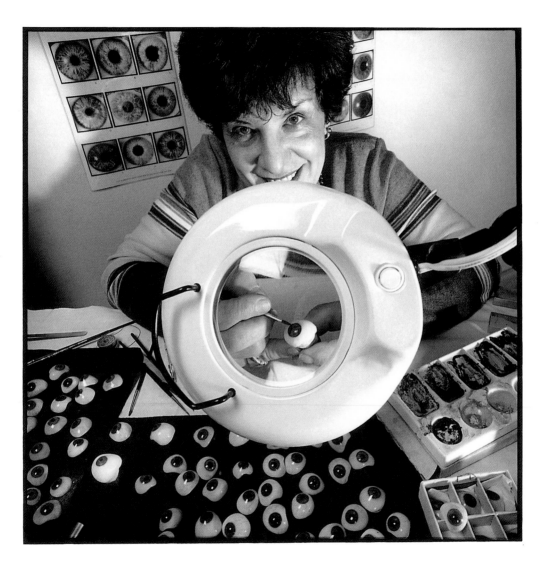

Pet Cemetery Owner
Taylor County, Texas

In Texas, just outside Abilene city limits, are two acres of land on which Lowell Queen began a pet cemetery thirty-two years ago. He estimates that to date he's interred as many as 1,500 dogs and cats at Pet Haven, which is located on a lane that bears the same name. At the entrance to the cemetery hangs a sign that reads: "Pet Haven Cemetery . . . because they have been a special member of your family." Inside, a typical tombstone reads: "Ring, loved as little brother." Small burial plots—three feet by three feet—cost $225; larger ones $425. But bad luck if "little brother" should happen to be larger than a rottweiler. That's as big a pet as each plot can accommodate.

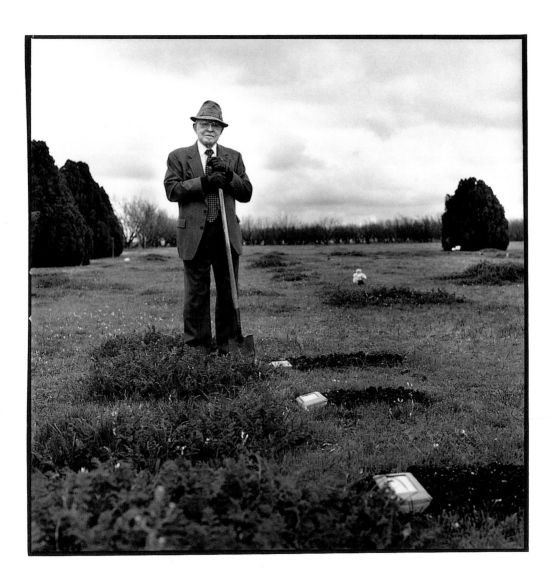

Beer Taster
Golden, Colorado

Of the hundreds of millions of beer drinkers in the world, there are few who spit out as much of it as Jeff Bell does every day. Judging by his slim appearance, you'd never guess that he's a beer taster—one of two official flavor evaluators of the eleven different Coors products. With up to 350,000 thirty-one-gallon barrels packaged weekly at Coors's Golden plant, Jeff tastes—and spits out—beer all day long. One of the perks of his job is frequent trips to Europe, where once again he's called upon to exercise his good taste by approving the flavor of shipments arriving from Colorado.

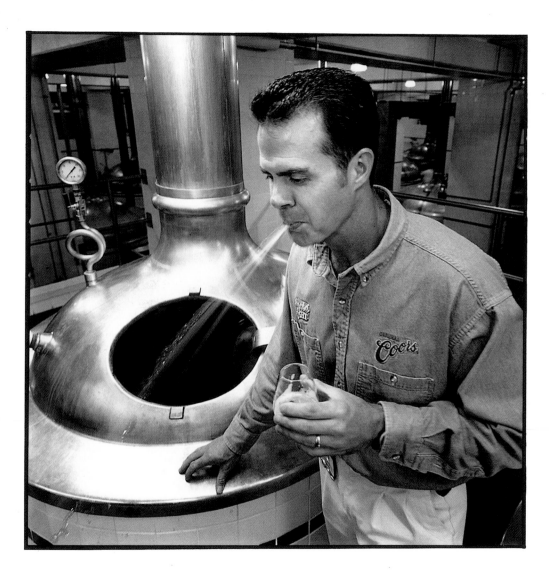

Pooper Scooper
San Fernando Valley, California

Tim Stone created his job of professional pooper scooper because he wanted free time to spend with his son. He sells his services with shovel and pail to dozens of dog owners in Los Angeles's San Fernando Valley. His company is called Scoop Masters, and he performs his duty once or twice a week with an open mind and lots of humor. His motto is "Your dog's poop is my soup."

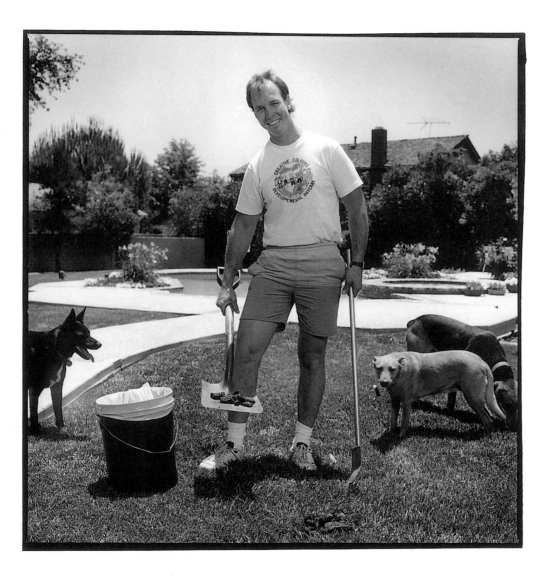

Bugler
Louisville, Kentucky

Though Steve Buttleman is a modest man, he toots his own horn, a 3 1/4-foot B-flat Blackburn bugle, before thousands of people on a daily basis. As punctual as a cuckoo clock, he makes his appearance ten minutes before each race at famed Churchill Downs, home of the Kentucky Derby. Standing on a deck in the center of the racetrack, he performs two rounds of "Call to the Post," a thirty-four-note cavalry tune, as the horses make their grand entrance onto the racetrack. Come rain or come shine, Steve plays nine to twelve times a day to mark the beginning of each new race to glory.

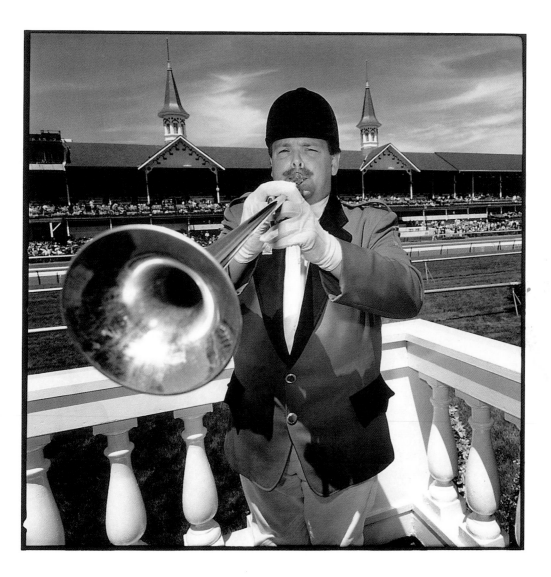

● Crack Filler
Keystone, South Dakota

He looks like a fly on Thomas Jefferson's nose, but Jeffrey Glanzer is doing the very important job of crack filling: repairing the wear and tear that has weathered our forefathers in the Black Hills of South Dakota since the sculpture on Mount Rushmore was begun in 1927. (It was completed in 1941.) The rangers who do this conservation work formerly used a mixture of granite dust, linseed oil, and white lead powder. However, since 1989 they've been using a silicone sealant. Maintenance is done according to a yearly schedule, and there's no denying that it's a monumental job.

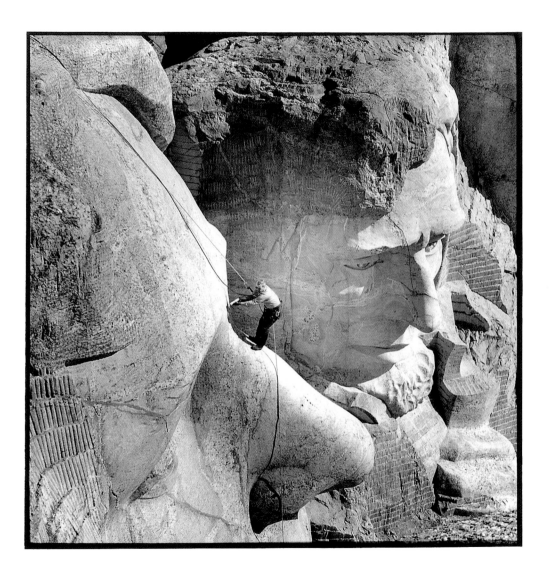

Sign Patroller
Las Vegas, Nevada

Las Vegas may soon rival Paris as the "city of lights," thanks in part to the Mikohn Lighting and Sign Company, an up-and-coming, award-winning manufacturer of electric signs based in Las Vegas. Though Mikohn makes and ships electric signs all over the world, employee Evan Bigelow services all their local installations. He checks for burnt-out bulbs and replaces them, as he is doing here at the Harley Davidson Café on the famous Strip. Bigelow's beat includes some twenty to twenty-five signs in this mecca of lighting, where to keep up with the ever-expanding growth of Las Vegas, new signs are being added every day.

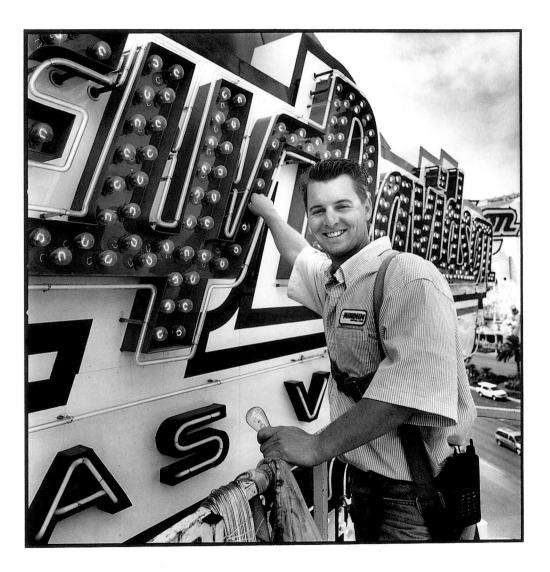

Fish Counter
Seattle, Washington

There's something decidedly fishy about Julie Booker's job. Working only during spawning season, from June through October, she stays awake some nights until one in the morning, counting fish every ten minutes. She works at the Ballard Locks, which separate Seattle's Lake Washington from the Puget Sound, and her fish counting helps to regulate the fishing rights in the area. Often Julie is joined by a roomful of tourists. At peak spawning time, Julie records sockeye on one counter and chinook on another. The most sockeye she's counted in a ten-minute period: 450. The most chinook: 75.

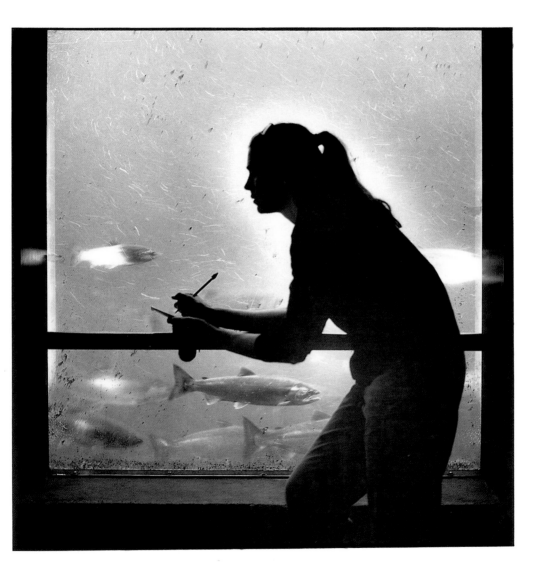

Body Piercer
Santa Cruz, California

Punching holes in navels, nipples, and noses is everyday fare for body piercer Scott Snyder, who has made his way up and down the West Coast. I found him performing a tongue piercing at Lovedog Tattoo and Art Studio in Santa Cruz, California. With his own assortment of piercings, as well as fully tattooed arms, Scott is a walking advertisement for his art.

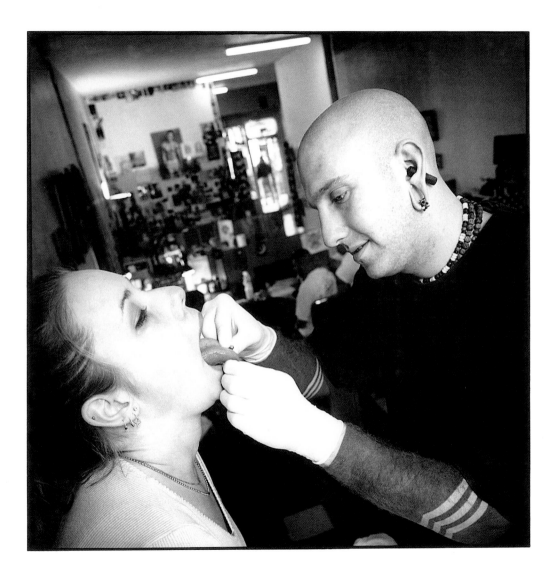

Duckmaster
Memphis, Tennessee

Seven days a week at precisely eleven in the morning, people from near and far gather at the Peabody Hotel in Memphis, Tennessee. The red carpet is rolled out, and five ducks accompanied by their duckmaster march from the elevator to the lobby to the tune of King Cotton's March. The web-footed five while away the day at the fountain in the center of the lobby. In the afternoon at the stroke of four, the fanfared-procession begins anew when the ducks ascend to their rooftop home. James Means is the duckmaster, a drill sergeant who's upstaged every step of the way by his fine-feathered friends.

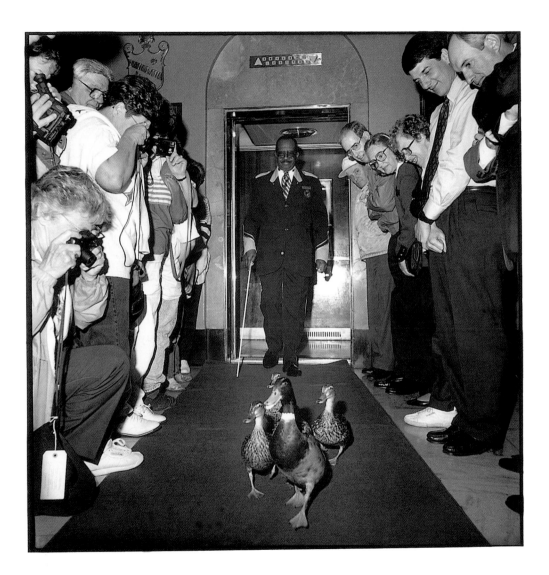

Oyster Shucker
New York, New York

How many oysters can an oyster shucker shuck if an oyster shucker shucks oysters all day? According to the manager of New York City's famous Oyster Bar, located on the lower level of Grand Central Station, 7.3 million oysters were served in the year 2000. Divide that by five days a week, and divide again by three—since Felix Guzman is one of three oyster shuckers at the Oyster Bar—and there's your answer. This picturesque eatery offers between sixteen and twenty different types of oysters every day. Any way you look at it, that's a lot of shucking.

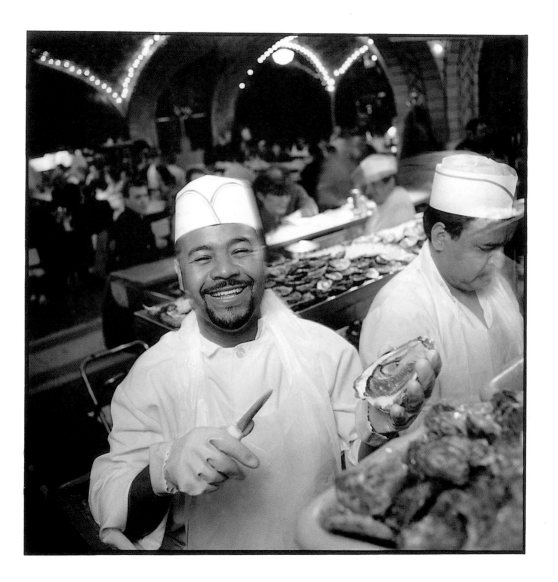

Alligator Trapper
Merritt Island, Florida

Bill Robb is one of thirty-seven state-appointed alligator trappers in Florida, his territory being Brevard County. Whether he's called upon to capture a nine-foot alligator under a trailer at the Kennedy Space Center or a twelve-footer in someone's backyard, one thing's for sure: the alligator in question has outlived his welcome. On duty twenty-four hours a day, seven days a week, Robb sometimes must lie in wait for his prey for hours on end. But once he's snared the enemy, he can usually subdue it merely by covering the eyes and taping the mouth shut.

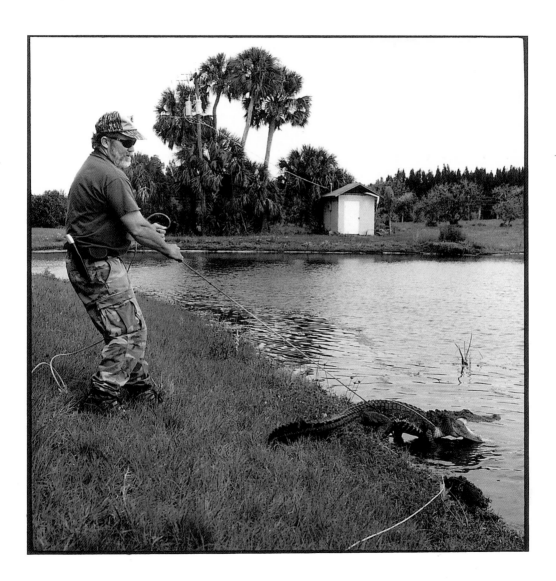

Gold Reclaimer
New York, New York

When Steve Landis examines an old tooth, what he sees is the gold. The fillings, along with broken gold jewelry, are melted down into tiny gold pellets—a thimble full yields one ounce, or $300 worth of gold, which he then resells to his jeweler clients. It's a craft his father practiced and passed on to Steve. Here, sitting in the tray of his scale, is an estimated $5,000 worth of gold—quite a toothsome sum of money.

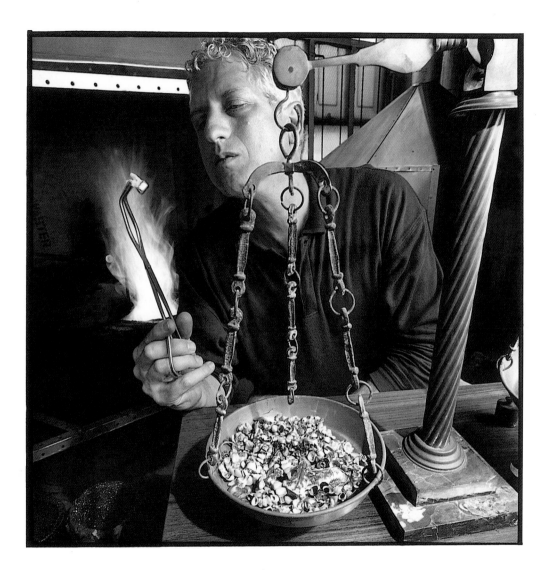

Riddler
Calistoga, California

The Schramsberg Vineyard in the Napa Valley is the only cellar in the United States solely devoted to producing barrel-fermented champagnes. In the process of making this sparkling wine, the bottles must be riddled—rotated back and forth at least thirty times over a period of four weeks. Riddling facilitates the removal of any sediment remaining in the bottle. Ramon Viera has been Master Riddler at Schramsberg since 1970. How many bottles can he riddle in a day? Forty thousand!

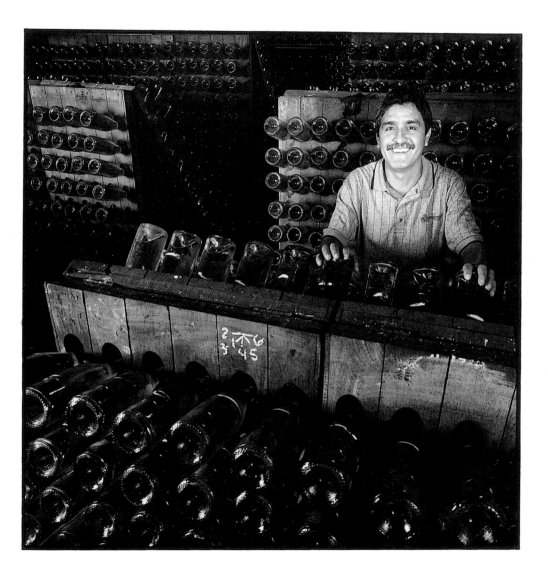

Oak Leaf Scrubber
Chicago, Illinois

The heat's really on when Thomas Kato goes to work. Laboring in temperatures of 165 to 180 degrees Fahrenheit, he provides patrons of the Division Street Bathhouse in Chicago with an old-fashioned treatment popularized in Russian bathhouses in days of yore: a soapy oak leaf scrub. The oak leaves are delivered to the bathhouse every July, hung up to dry, then made into two-foot-long brooms that are used to exfoliate patrons throughout the year—for a mere ten dollars in addition to their twenty-two-dollar entry fee. Since heat rises, Kato raises the broom up to the top of the room, then brings it down over the waiting body. After the scrub, it's back to reality—the patron's head is doused with cold water.

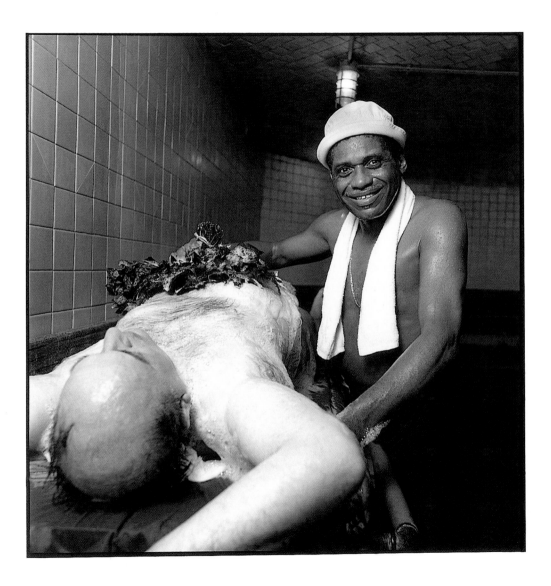

Matzo Cracker
New York, New York

When it comes to breaking bread, Jose Villar is something of a specialist. Proving that you don't have to be Jewish to break matzos, he's been breaking them by hand at the Streit's Matzo factory on New York's Lower East Side for the past fifteen years. Since 1925, Streit's has always employed someone to count the sheets of unleavened bread as they emerge from the ovens, and someone else to crack them into the one-pound portions that are carried along to their next stop—the packing department—in overhead baskets. Though the process could certainly be automated, Streit's prefers the human touch.

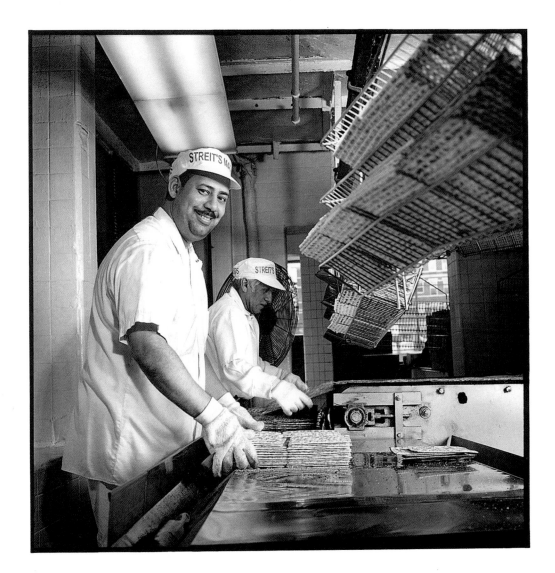

Tampon Tester
McElhattan, Pennsylvania

Daniel Raudabaugh doesn't mind telling women what he does for a living; in fact, he finds that it makes for interesting conversation. Working the second shift at First Quality, he spends from 3 to 11 P.M. testing tampons— regular, super, and plus sizes—for such traits as absorbency, head projection, and cord strength—the industry-wide standards set by the FDA. First Quality turns out tampons twenty-four hours a day, five days a week, producing some one to two million a day. Raudabaugh himself is likely to spot test some 125 pieces out of 500,000 or more. Few men can relate to women as intimately as he does.

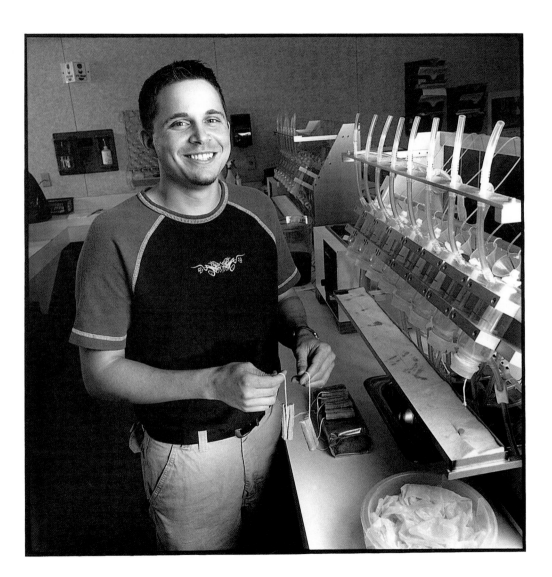

Dog Handler
New York, New York

Backstage at the Westminster Kennel Club Dog Show, an annual event at Madison Square Garden, stars like this little toy poodle suffer through up to ten hours of primping for their moment in the spotlight. Kaz Hosaka bathes, blow dries, shaves, powders, snips, and finally hair sprays his dog to perfection, then runs him around the arena for all to admire. Kaz loves what he does and has many ribbons to show for it.

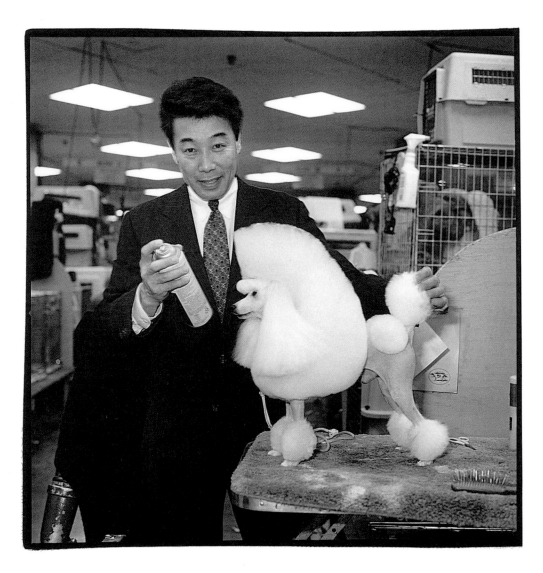

Snake Venom Extractor
St. Cloud, Florida

Having been badly bitten ten times hasn't deterred George Van Horn from his chosen profession, nor kept him away from his home, the Serpentorium, near Orlando, Florida. He resides there with his wife and children, not to mention between six and seven hundred snakes of every kind, from the common eastern diamondback to the more unusual African mamba. Along with his wife, who works as his assistant, Van Horn demonstrates daily the fine art of venom extraction before mesmerized visitors. Meanwhile, the poison he extracts is put to good use by universities and pharmaceutical houses in all types of physiological research.

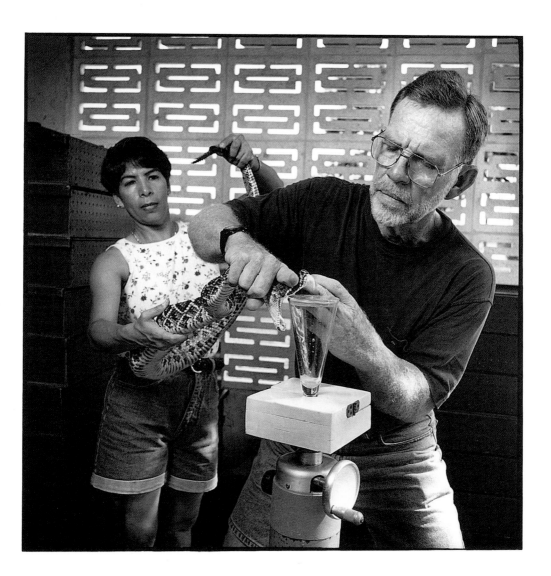

Headmistress
New York, New York

Hidden away in the Chelsea neighborhood of New York City is a unique and exclusive little school. Veronica Vera is the creator, founder, and dean of Miss Vera's Finishing School for Boys Who Want to Be Girls, the world's first cross-dressing academy. According to Miss Vera, 60 percent of her student body is married. The curriculum includes such courses as high heel walking, body sculpting with corsets, makeup, voice, and flirting fundamentals. The term culminates with a final exam: dressing up and appearing in public—as a woman, naturally.

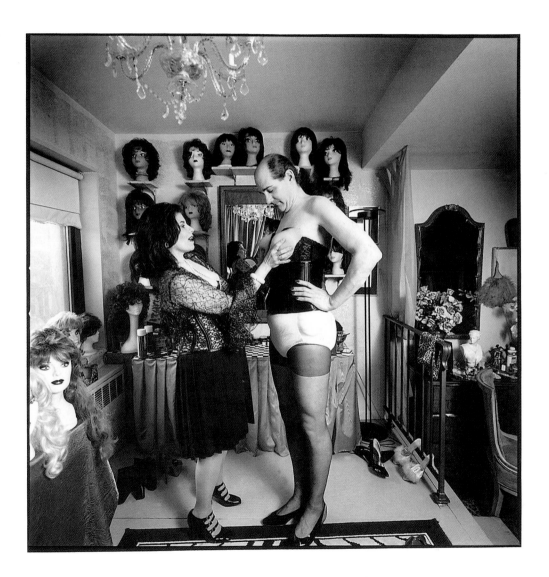

Stanley Cup Keeper
Toronto, Ontario

The most revered cup in the world, the Stanley Cup, may also be the best traveled. And wherever it goes, along goes keeper of the cup, Phil Pritchard, as chaperone. Though Toronto, home to the Hockey Hall of Fame, is the cup's home base, this trophy sees its share of the world. Every year it plays a part in hometown celebrations with every member of the team that won the cup that year. Weighing 34 1/2 pounds, at 35 1/4 inches tall and 17 1/4 inches across, it's also the Big Bertha of cups, and when it flies, it sometimes gets a seat of its own on the airplane. Needless to say, Phil Pritchard is always in the adjacent seat.

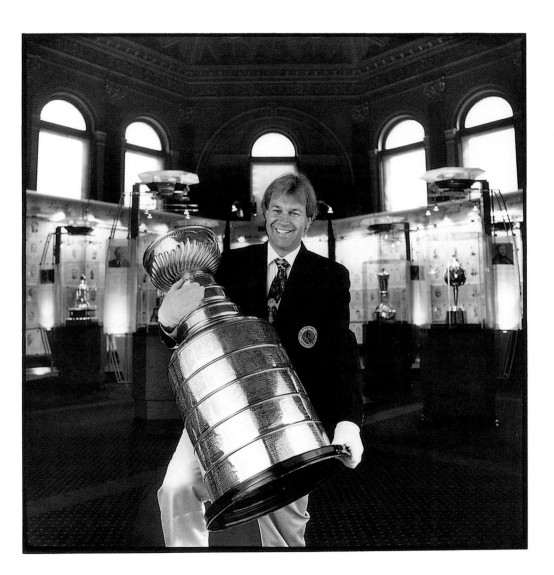

Video Game Tester
Glen Cove, New York

Brian Alcazar is the envy of his peers. What teenager wouldn't give his eye teeth for the chance to play video games eight hours a day, five days a week—and get paid for it? At Acclaim Entertainment, Alcazar is employed, along with a roomful of male and female high school graduates, to do exactly what he's been doing since childhood. You might wonder if he gets bored playing the same game for months on end. No siree, he just gets better.

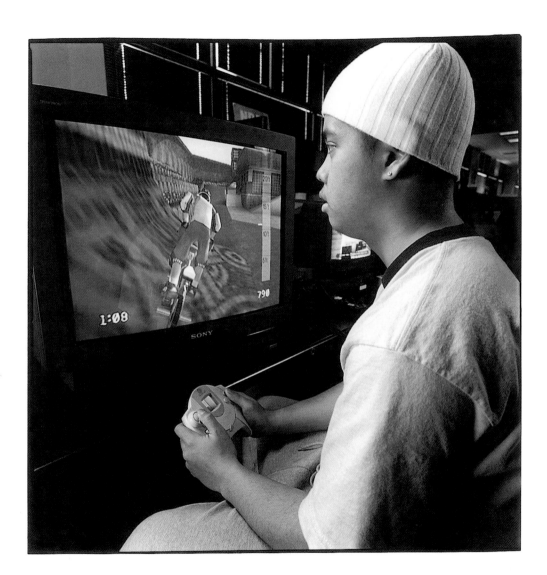

Colonics Therapist
New York, New York

We can wash our outer selves by ourselves, but to clean our insides takes someone with the special skills of colonics therapist Brigit Krome. Her job: to administer colon irrigations—think of them as glorified enemas—that control the inward flow and outward expulsion of water. A colon irrigation generally takes between a half hour and an hour. During this time, as many as thirty gallons of water are propelled into, and then expelled from, the colon through the rectum, several ounces at a time. Some consider the colon the body's own sewage system, in which case Krome could be viewed as its consummate plumber.

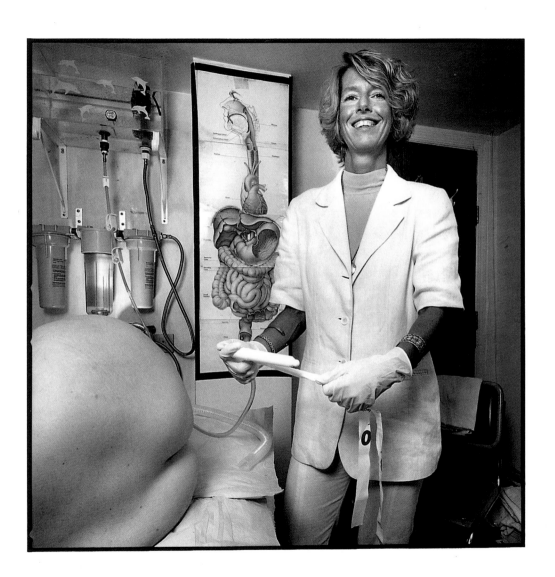

Acknowledgments

My deepest expression of gratitude goes to Joanne Jaffe for her undying friendship, her unwavering interest in this book, and her enormous help with the first edit. Grazie infinite to Stefano Lecci for his companionship and for helping me in any and every way possible. Special thanks also to my friend and fellow photographer Maria Ferrari for her assistance in so very many ways. My dear friend Todd Heughens gave the book its cover and for that and his friendship I will forever be grateful. Cheryl Wiesenfeld and Gayle Sand have both helped me in a myriad of ways that I couldn't begin to count. And much thanks to Randy Dunbar, who was there in the beginning, and to my dear friend Marc Friedland.

I am deeply indebted to all the people who gave me suggestions or facilitated my efforts in contacting the subjects. Thank you to Joy Nagy, Carol Cellucci, Dianne Stasi, Allan Ishac, Bobby Edwards, Peter Fodera, David Evans, Suzie Elmiger, Ken Schuler, Dr. Edward Lipke, Chris Blackburn, Sam Wenger, Nina Wachsman, Dr. Arthur Brown, Jenneen Ameres, Sandi Schulz, David Blue, Mike Pflaum, Jack Wild, Mike Mahovlich, Mary Jane Ryan, Bruce Silverglade, David Lawrence, Tony Amato, Ruben Rivera, Larry Cisewski, Jim Steinblatt, Patricia Harrington, and Tootie Madison.

I've had many assistants, both trained and untrained, who lent a helping hand. Thank you Eileen Zegar and Zach Miller in Baltimore; Catherine Berge, Sharon Oddson, Joyce Rudolph, Karen Abrams, and Ellen

Starr in the New York area; Anne Simmons and Martha and David Osler in Massachusetts; Tim Sutherland in Texas; and my brother, Alan Schiff, in South Dakota.

My gracious out-of-town hosts deserve a mention as well. They are Michael Lasky and Annica Rose in Santa Cruz; Darlene and Nick Carter in Denver; Cynthia Ploski in Trinidad, Colorado; Eliza Meyn in Sonoma; Joyce and Steve Mathias in Florida; Karen and Alan Schiff in Grand Junction; Cherry and Doug duMas in Seattle; my aunt, Gloria Weinberg, in Southern California; and Giulio Taddei, Jeremy Crow, and Mauro Monasterio in Chicago. Thank you for your hospitality

There has been a host of admirers and supporters of this book, most importantly, Joni Evans, who in the early stages gave me the courage to persevere; but it was Phil Wood, with his unparalleled enthusiasm, who brought the project to realization and Holly Taines White who smoothed over the rough edges. Thank you all so much.

Thanks to my sister, Judy Schiff, for always keeping me well fed. And most importantly, thank you to my mother, Shirley Schiff, who is a constant source of support and even served as one of my untrained assistants, and to my late father, Joseph Schiff, to whom I dedicate this book. He was the first working man in my life, was with me for one of my favorite photographs in this collection, and is with me still in my heart.

Index

The End